Lunar Tunes
by
Wallace Wood

Wally Wood's Final Graphic Novel

Combining the wit that made Wood a star at *MAD* with the far-out settings that made him famous on *Weird Science,* only a few *Lunar Tunes* pages originally saw print in *Witzend* but Vanguard has published this, *The Complete Lunar Tunes.* Classic Wood characters Bucky, robot Iron Myron, Pip, Nudine and Snorky are joined in their cosmic excursions by a surreal parade including Russians, JFK, Bogart, Bob Hope, Elton John, Jack Webb, Patty Hurst, Playboy bunnies, Wood himself and the Rolling Stones! Lunar Tunes is a last-gasp, complete with nudity, from one of the fathers of the Underground Comix movement -- the ultimate example of Wood's self-deprecating motto: "Never draw what you can copy; never copy what you can trace; never trace what you can cut and paste."

"*Lunar Tunes* is the last comics work Wood did before he killed himself. You can plainly see the struggle in the book. Wood has called all his old characters together for one last strut onstage before he exits. Wally (God) is looking down sadly onto the little world of his creation. This work... cries out."
 -- *Forty Cartoon Books of Interest* (Buenaventura Press, 2006)

"The wit in these strips is a kind of cartoon martini of burlesque vermouth shaken with Lewis Carroll gin. Throw in a couple olives pickled in the brine of bad relationships and voila! A curious... interesting footnote to a tremendous career."
 - - www.chrisallenonline.com

"A troubled yet entertaining, bizarre, but unmistakably *individual* project. I found it quite spellbinding. ...a boon for every Wood fan, though non-fans will absolutely not want to start here. A compelling portrait of a talent's struggle to deliver just a few more bursts of expression before such things are no longer possible."
 -- Jog - The Blog

"I find *Wally Wood: Lunar Tunes* utterly fascinating."
 -- Eisner & Harvey Award-winning *Palookaville* cartoonist-designer, Seth

Vanguard Productions

Lunar Tunes
by
Wallace Wood

CREATED, WRITTEN AND DRAWN BY WALLACE WOOD
Covers by Wallace Wood and J. David Spurlock

EDITING & PRODUCTION BY J. DAVID SPURLOCK
PUBLISHED BY VANGUARD PRODUCTIONS
Dist. Office Lakewood, NJ • Editorial Miami FL

SPECIAL THANKS TO BILL PEARSON,
and to Conrad Wolters for production assistance,
and to Rene Dorenbos for access to the Lunar Tunes original art.

Paperback Edition ISBN 1–887591–86–9 $9.95

www.vanguardpublishing.com • www.wallacewoodestate.com

1st Printing, Sept., 2005. • 2nd Printing, June, 2012.
Printed in Canada

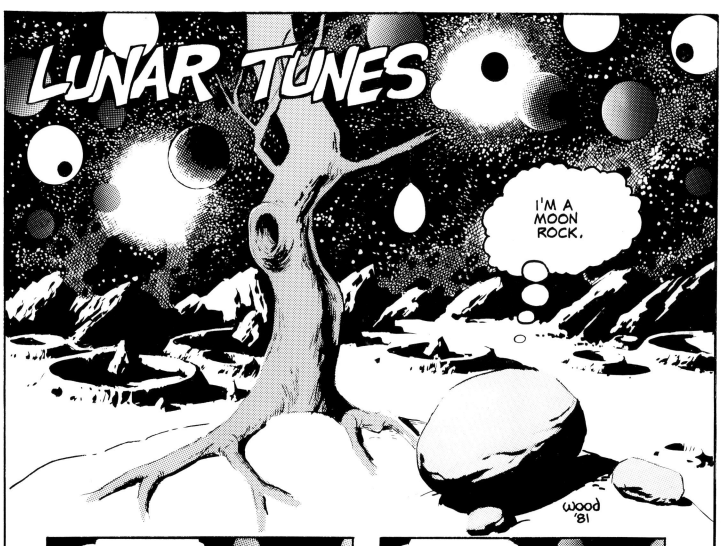

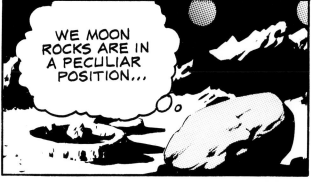

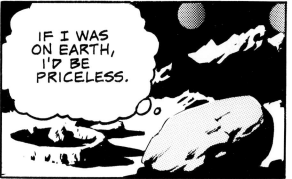

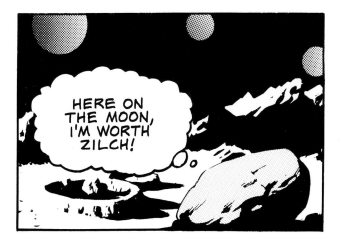

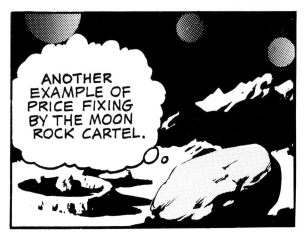

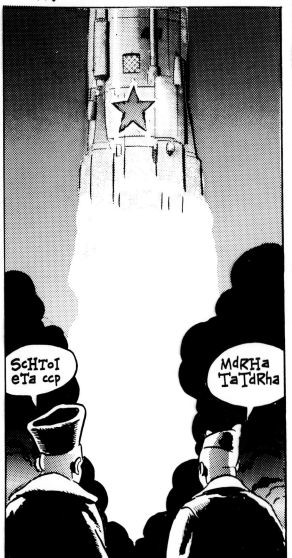

MEANWHILE, A SPACESHIP LEAVES EARTH...

ScHToI eTa ccp

MdRHa TaTdRha

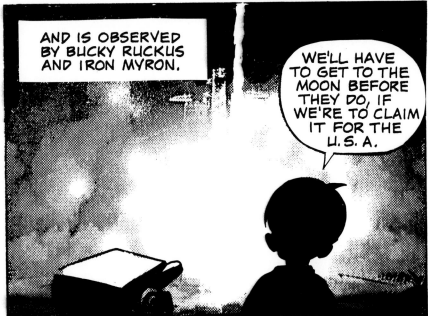

AND IS OBSERVED BY BUCKY RUCKUS AND IRON MYRON.

WE'LL HAVE TO GET TO THE MOON BEFORE THEY DO, IF WE'RE TO CLAIM IT FOR THE U.S.A.

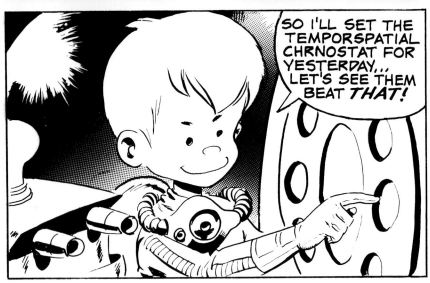

SO I'LL SET THE TEMPORSPATIAL CHRNOSTAT FOR YESTERDAY... LET'S SEE THEM BEAT *THAT!*

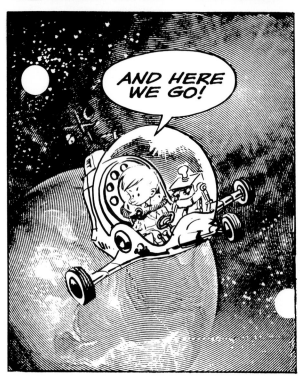

AND HERE WE GO!

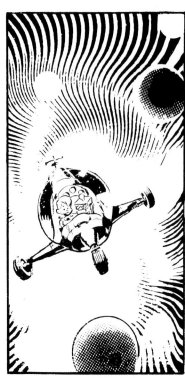

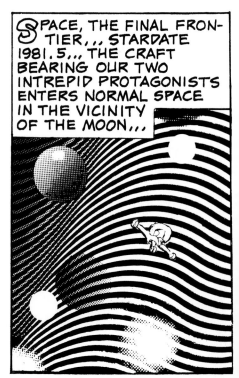

SPACE, THE FINAL FRONTIER... STARDATE 1981.5... THE CRAFT BEARING OUR TWO INTREPID PROTAGONISTS ENTERS NORMAL SPACE IN THE VICINITY OF THE MOON...

4

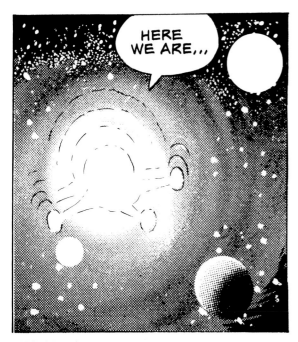

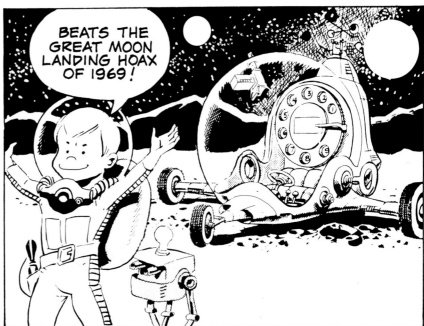

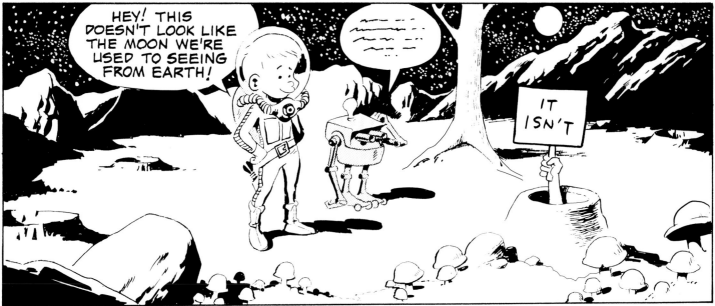

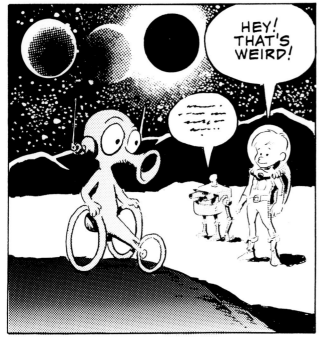

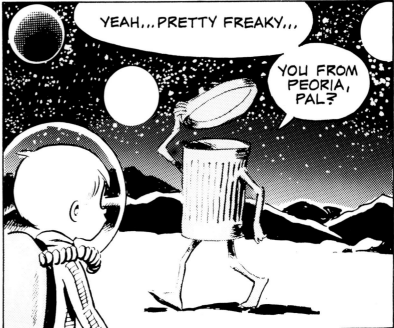

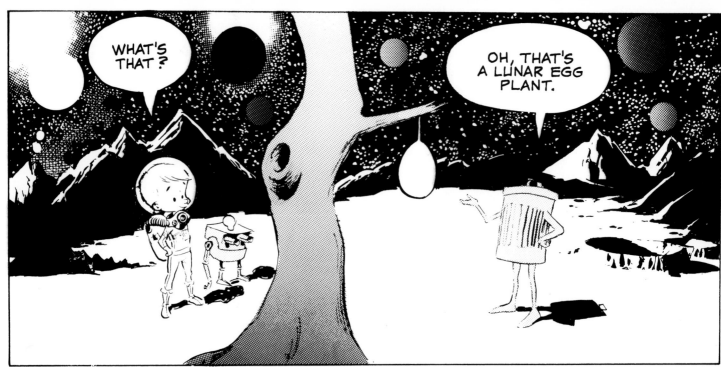

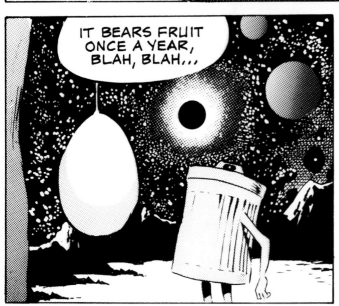

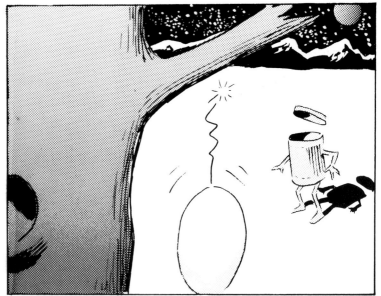

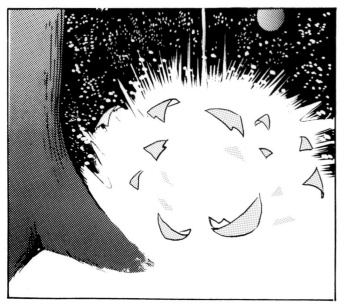

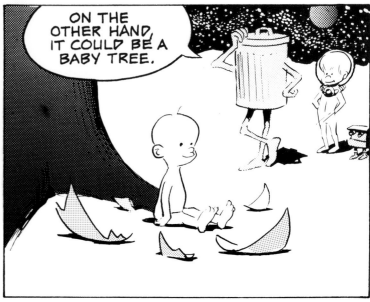

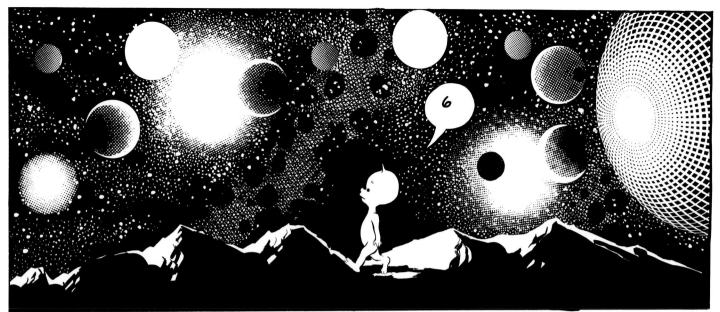

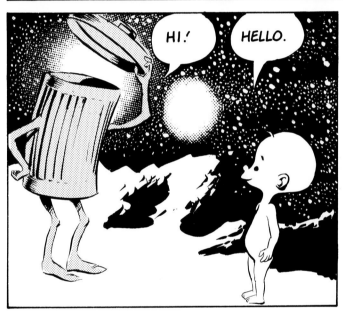

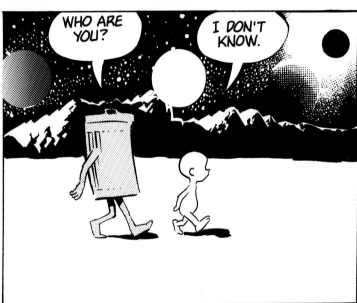

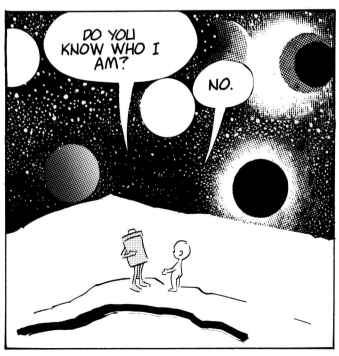

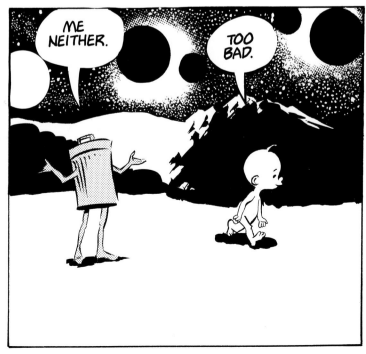

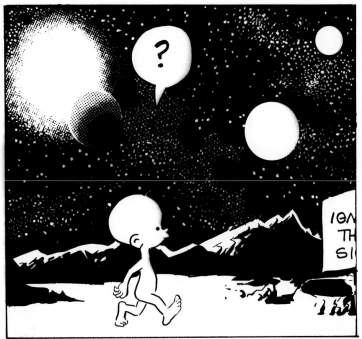

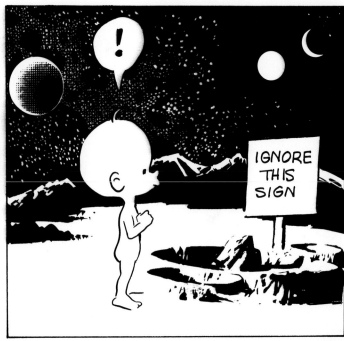

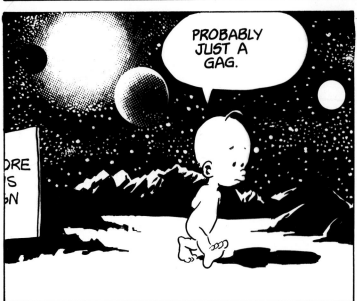

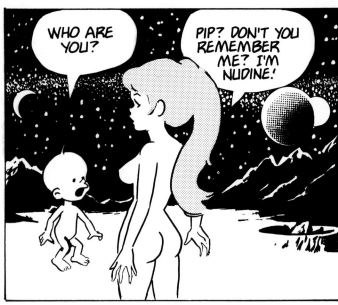

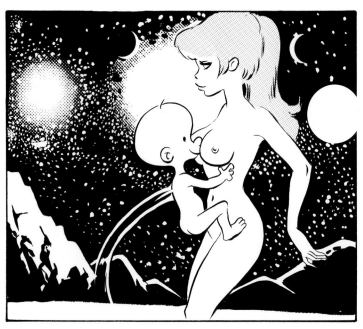

8

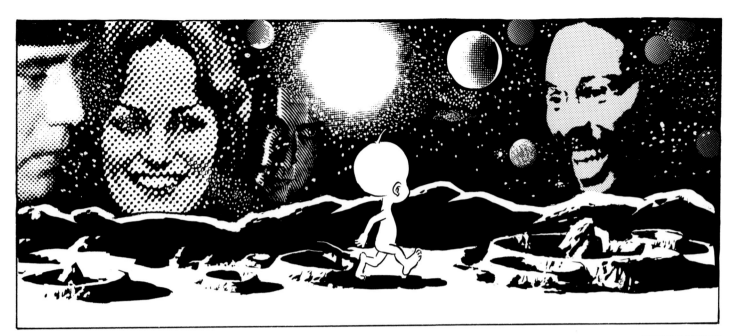

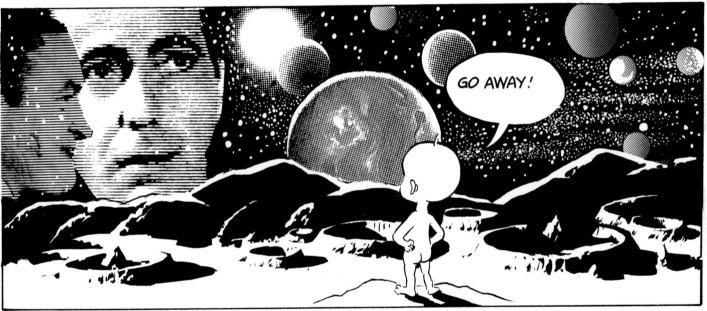

GO AWAY!

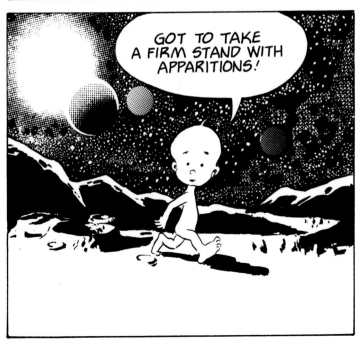

GOT TO TAKE A FIRM STAND WITH APPARITIONS!

Pipsqueak Pig Dictionary

Person n. (per -zún) female human, as in 'chairperson,' 'salesperson,' etc.

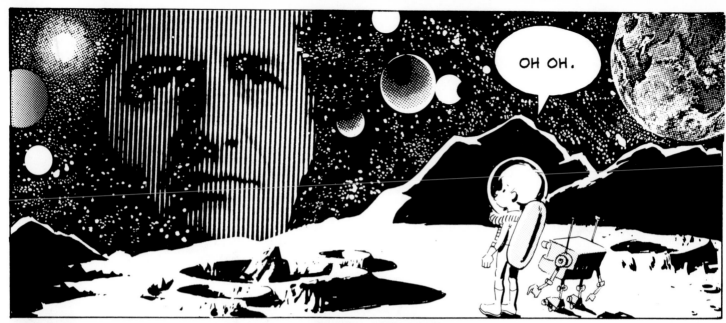

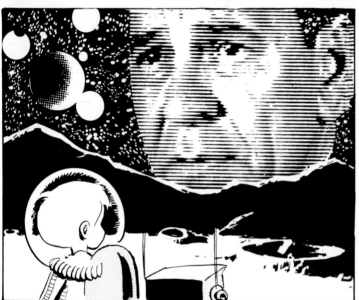

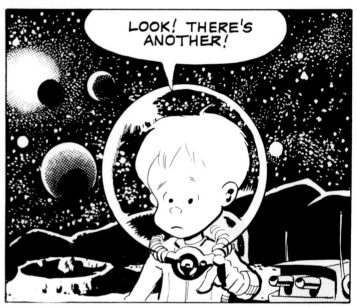

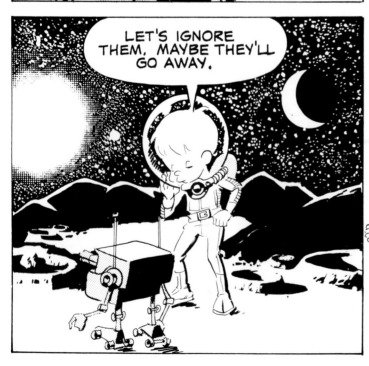

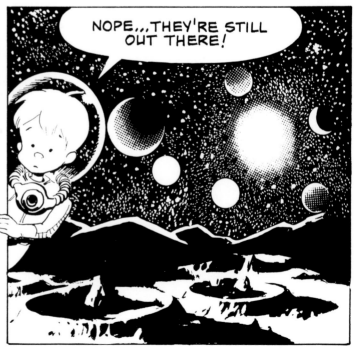

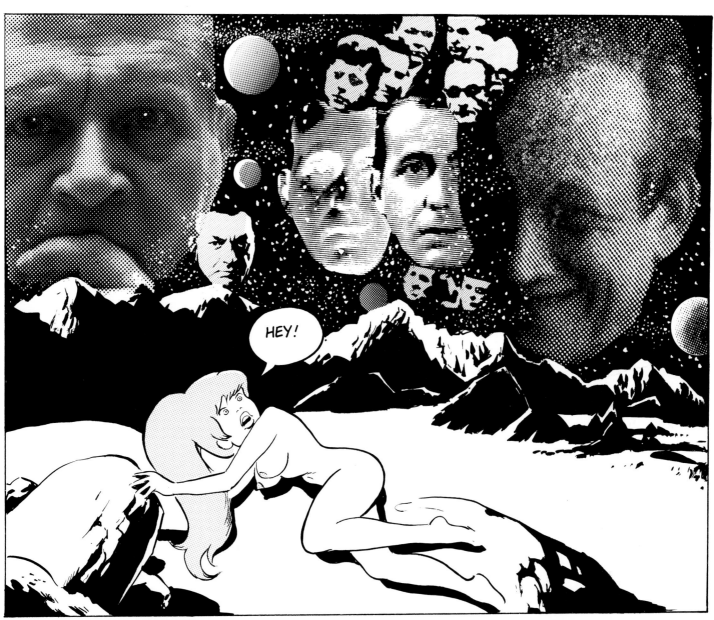

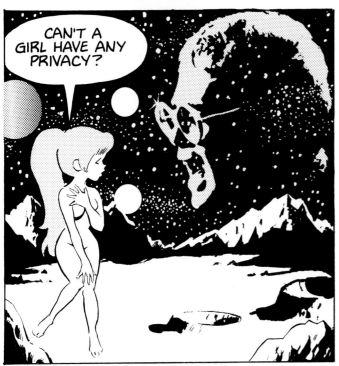

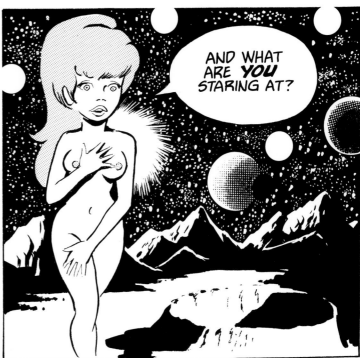

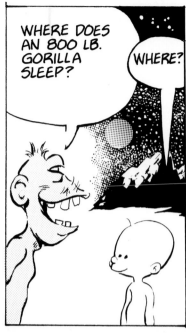

WHERE DOES AN 800 LB. GORILLA SLEEP?

WHERE?

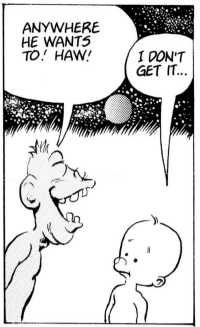

ANYWHERE HE WANTS TO.' HAW!

I DON'T GET IT...

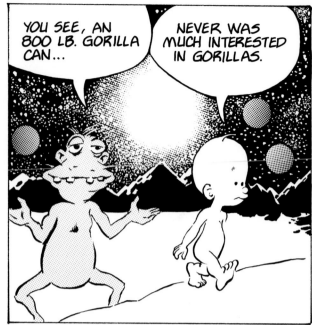

YOU SEE, AN 800 LB. GORILLA CAN...

NEVER WAS MUCH INTERESTED IN GORILLAS.

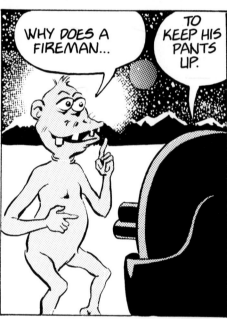

WHY DOES A FIREMAN...

TO KEEP HIS PANTS UP.

WHY DOES A CHICKEN...

TO GET TO THE OTHER SIDE.

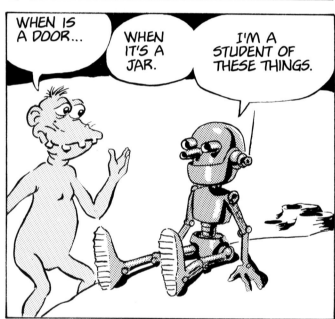

WHEN IS A DOOR...

WHEN IT'S A JAR.

I'M A STUDENT OF THESE THINGS.

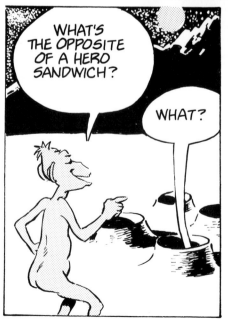

WHAT'S THE OPPOSITE OF A HERO SANDWICH?

WHAT?

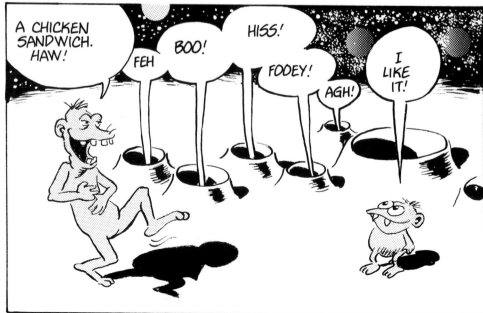

A CHICKEN SANDWICH. HAW!

FEH

BOO!

HISS.'

FODEY!

AGH!

I LIKE IT!

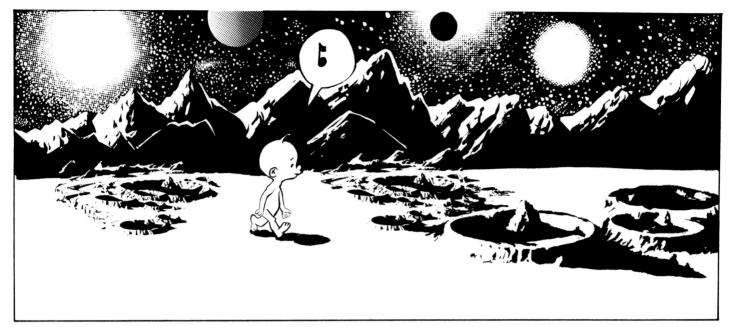

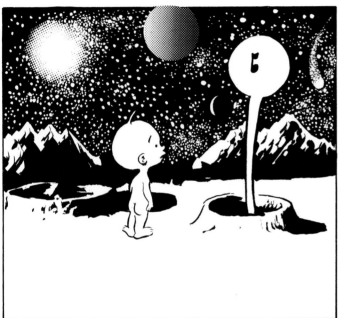

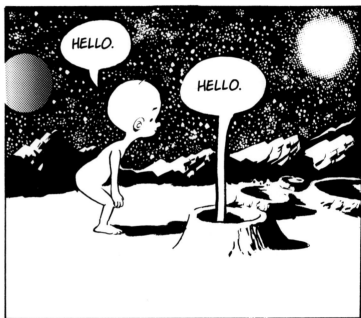

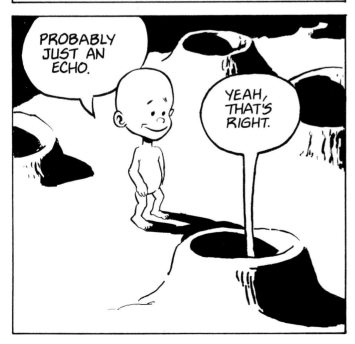

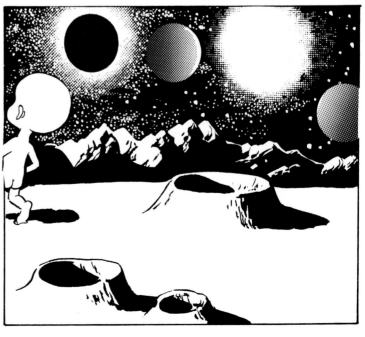

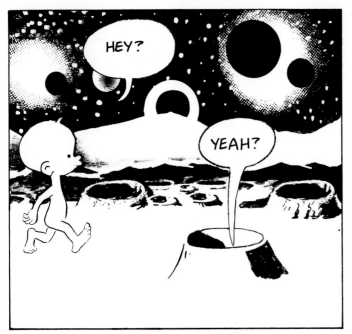

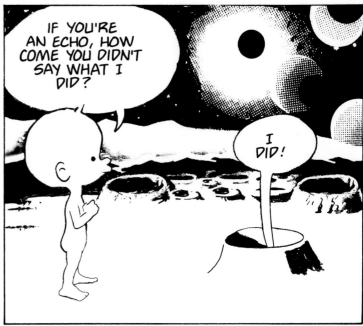

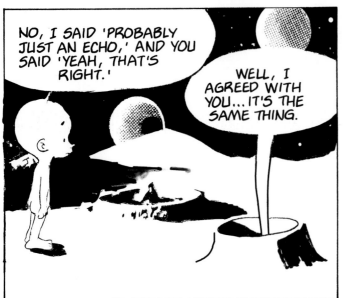

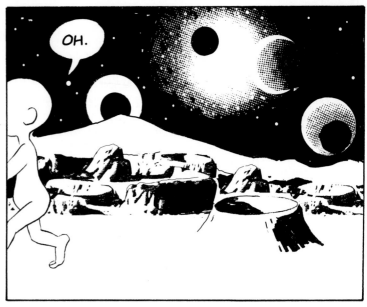

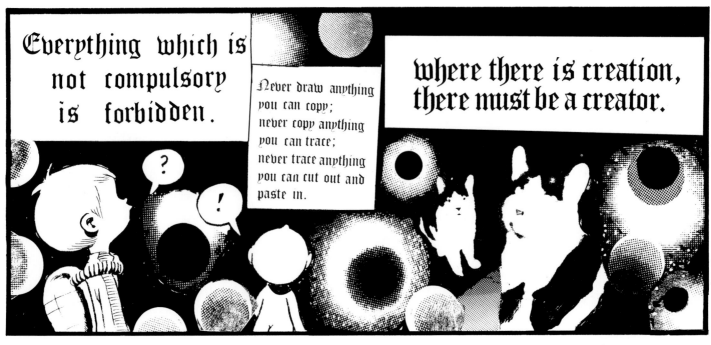

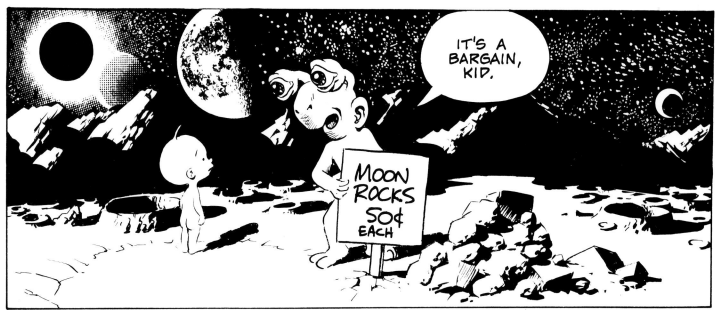

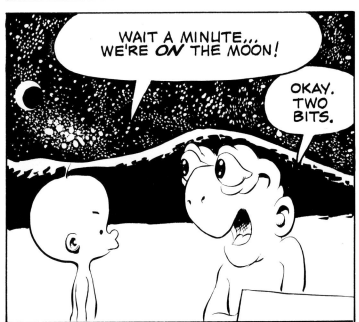

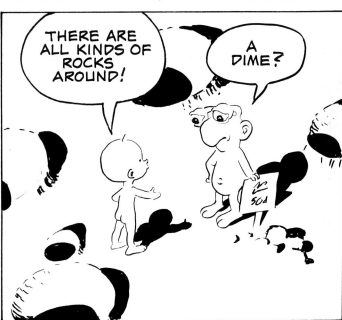

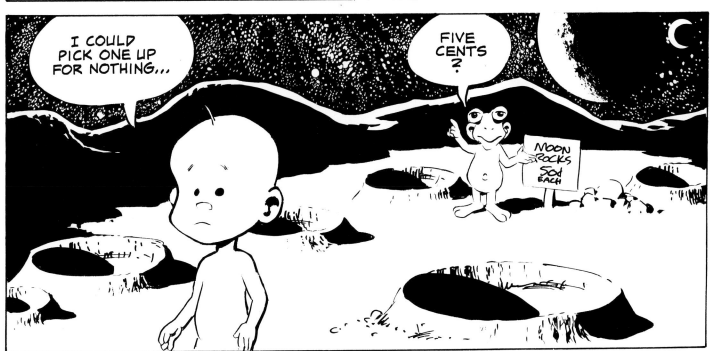

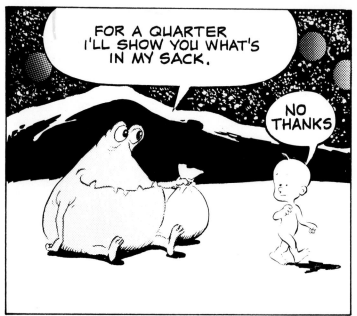

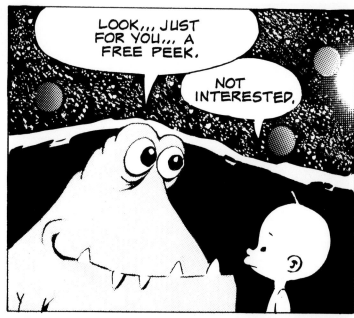

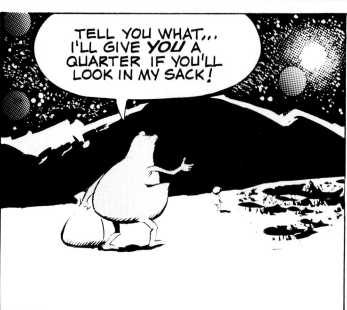

16

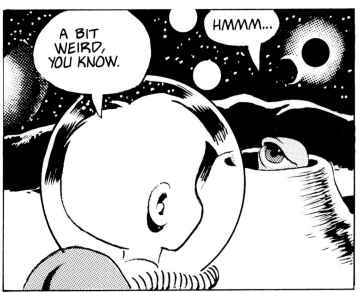

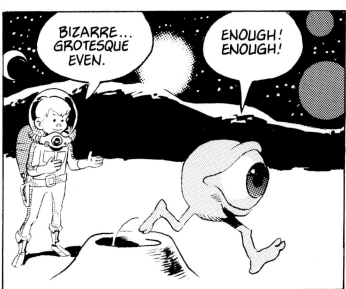

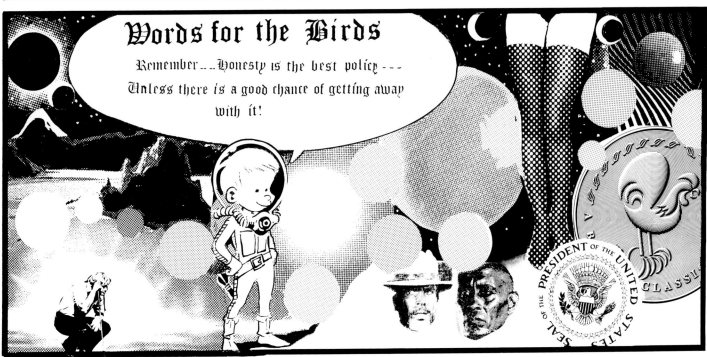

17

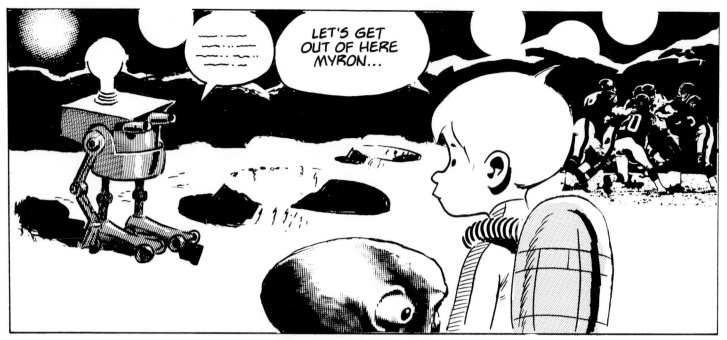

Never draw anything you can copy; never copy anything you can trace; never trace anything you can cut out and paste in.

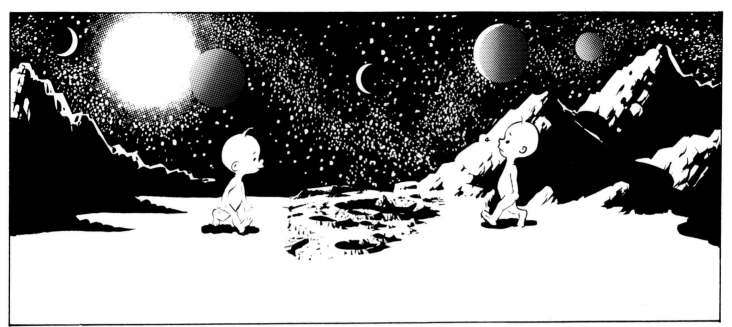

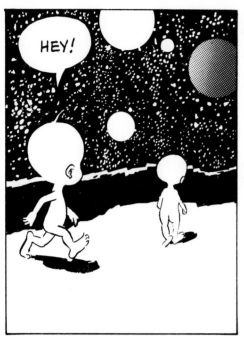

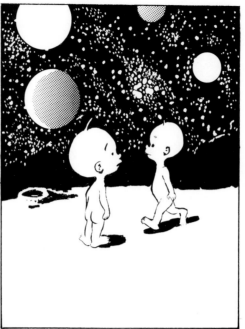

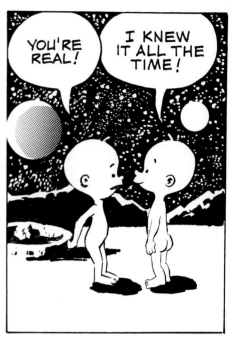

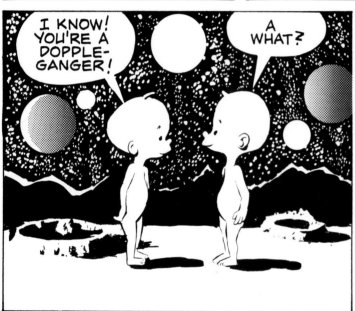

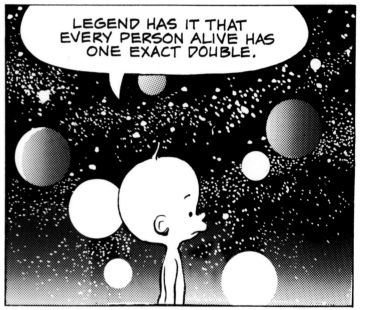

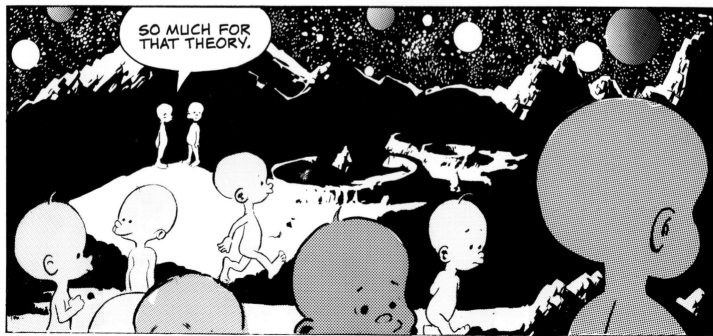

20

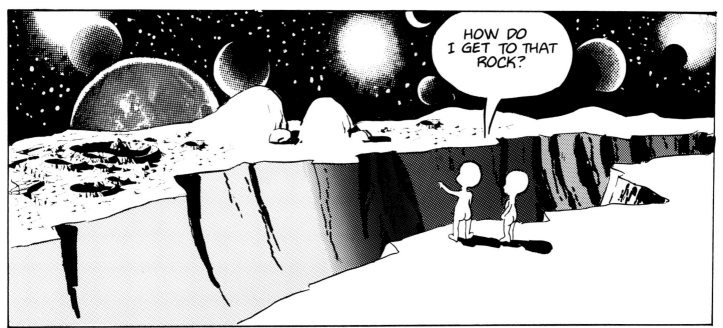

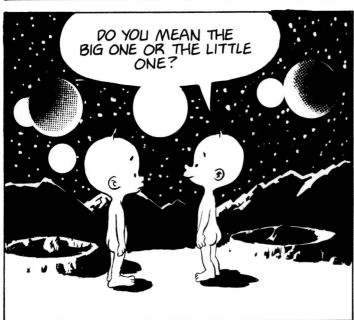

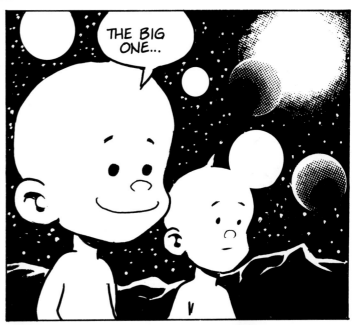

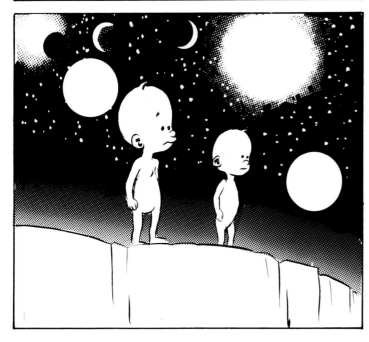

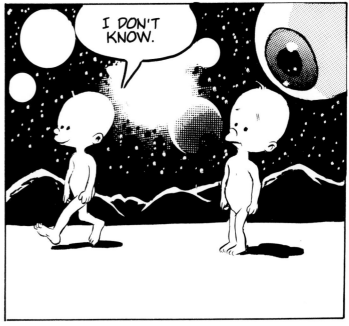

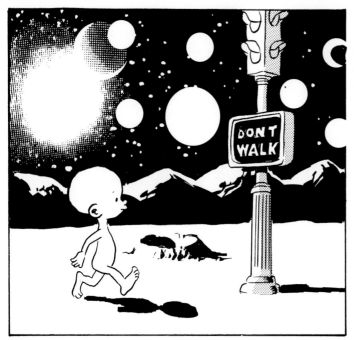

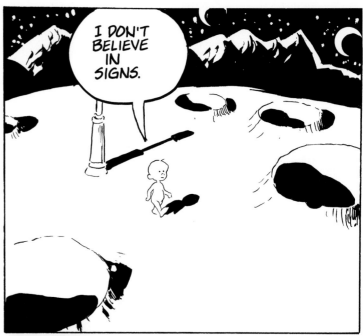

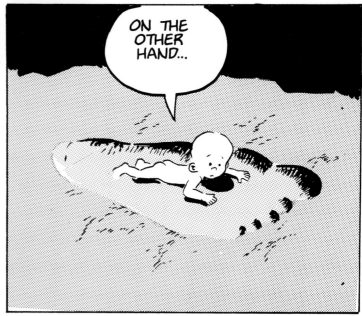

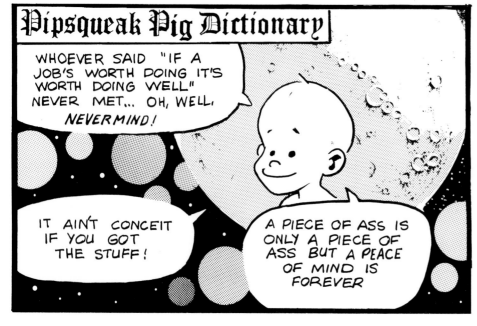

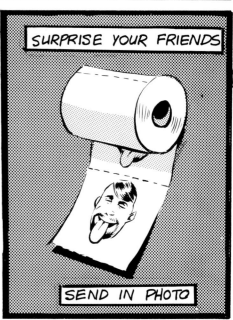

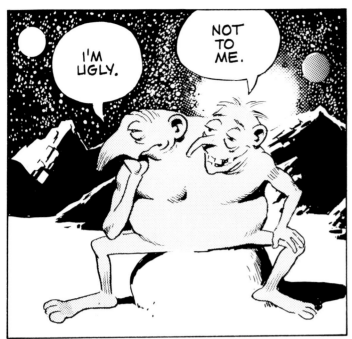

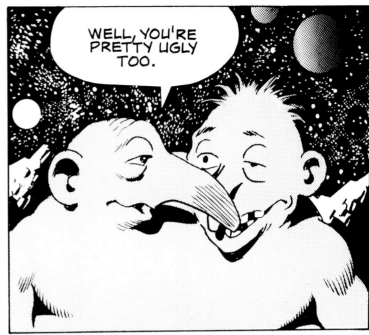

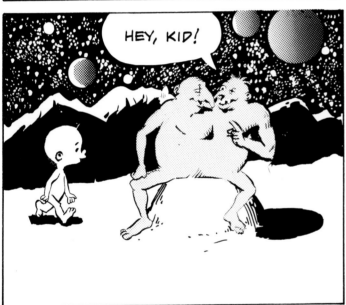

23

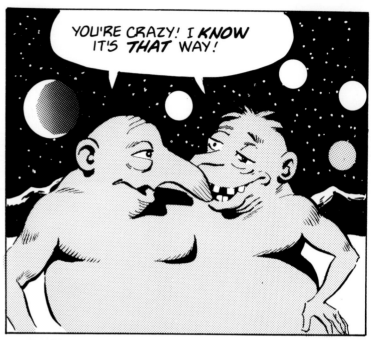

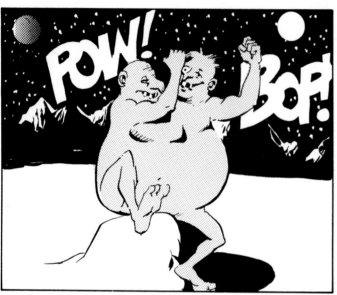

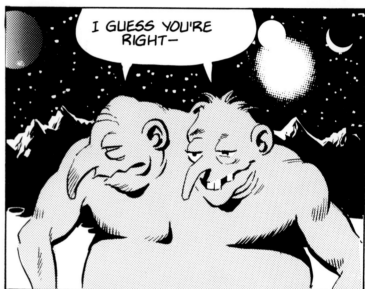

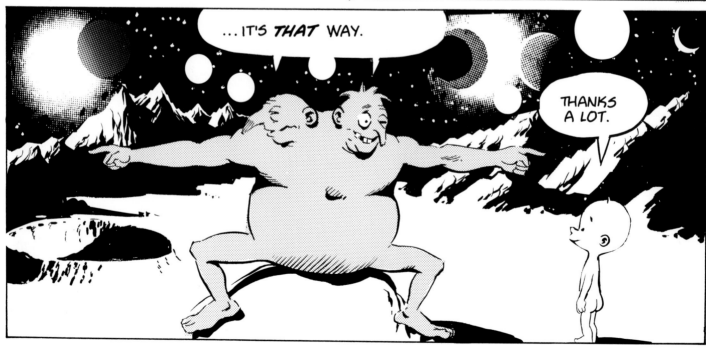

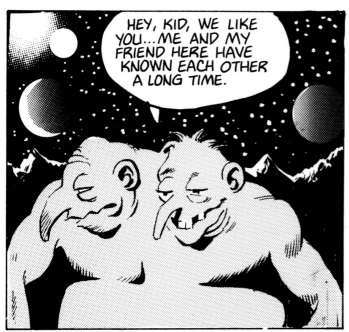

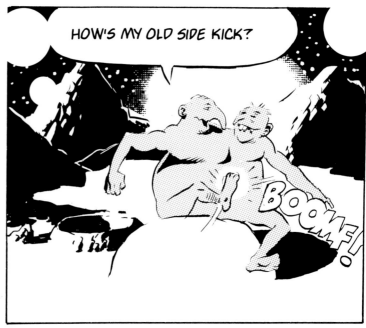

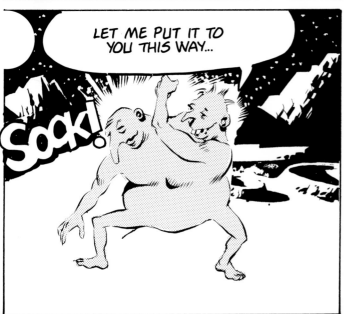

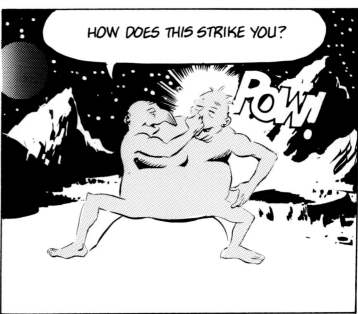

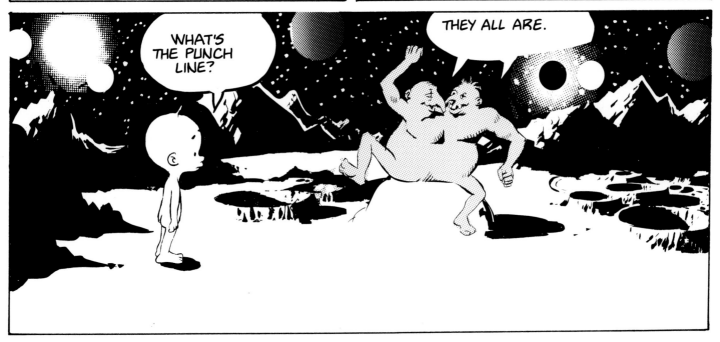

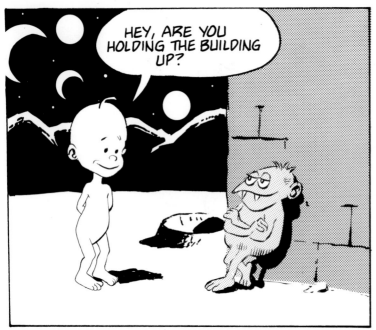

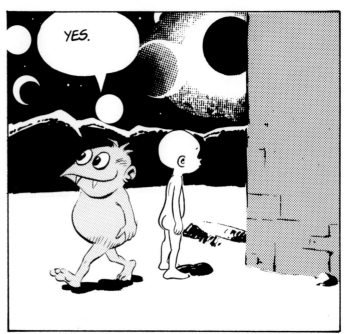

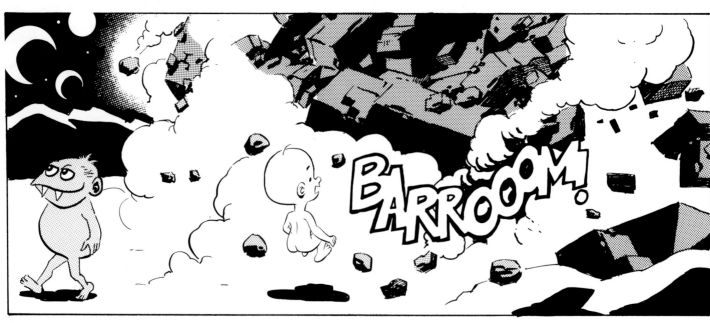

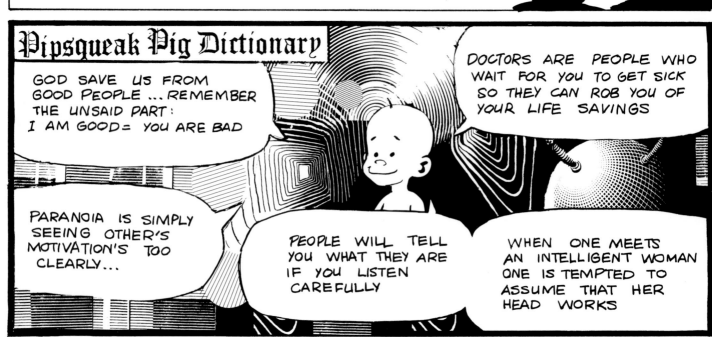

Pipsqueak Pig Dictionary

GOD SAVE US FROM GOOD PEOPLE ... REMEMBER THE UNSAID PART: I AM GOOD= YOU ARE BAD

DOCTORS ARE PEOPLE WHO WAIT FOR YOU TO GET SICK SO THEY CAN ROB YOU OF YOUR LIFE SAVINGS

PARANOIA IS SIMPLY SEEING OTHER'S MOTIVATION'S TOO CLEARLY...

PEOPLE WILL TELL YOU WHAT THEY ARE IF YOU LISTEN CAREFULLY

WHEN ONE MEETS AN INTELLIGENT WOMAN ONE IS TEMPTED TO ASSUME THAT HER HEAD WORKS

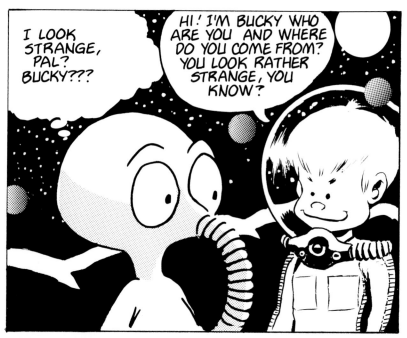

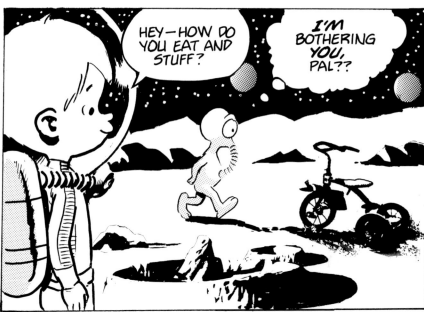

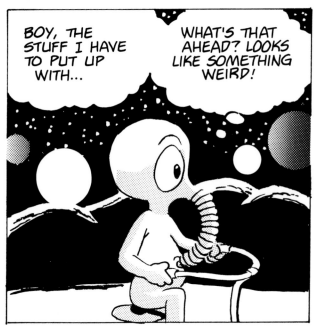

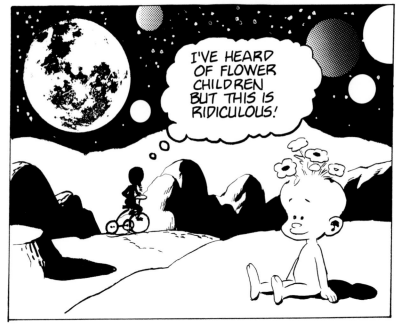

27

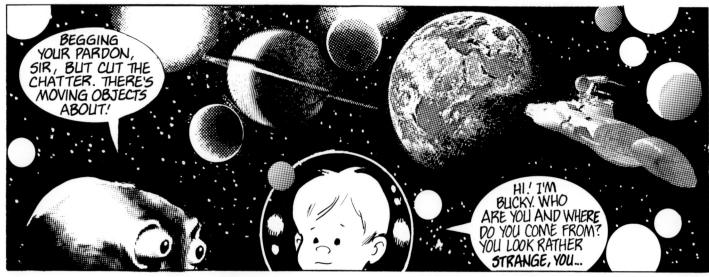

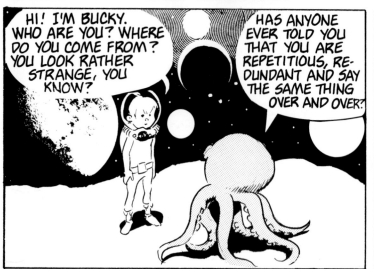

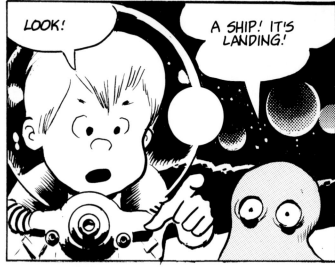

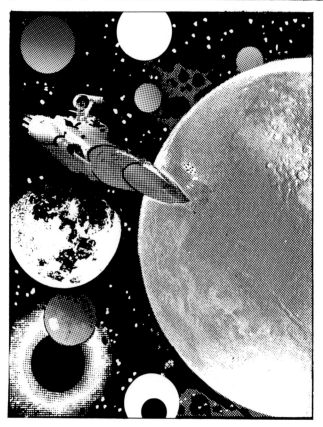

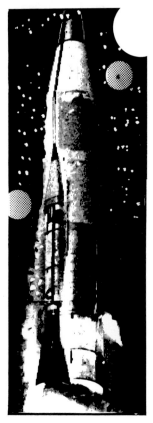

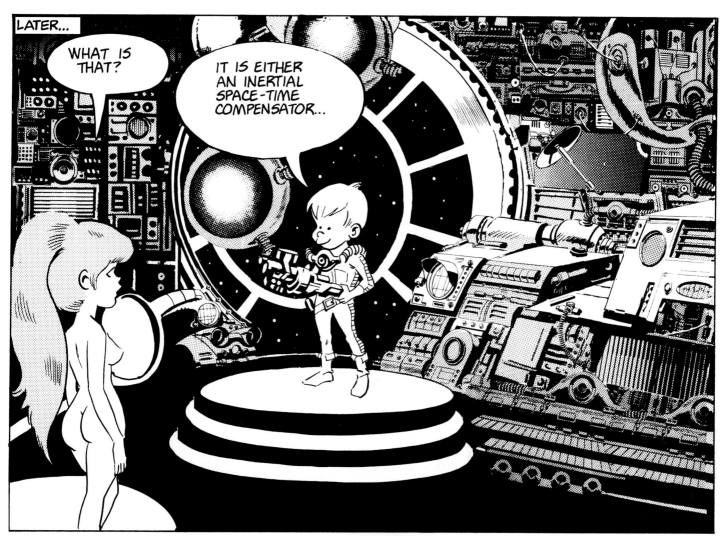

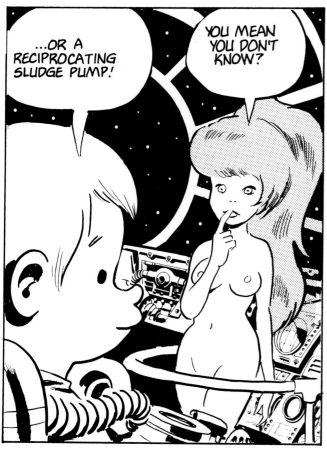

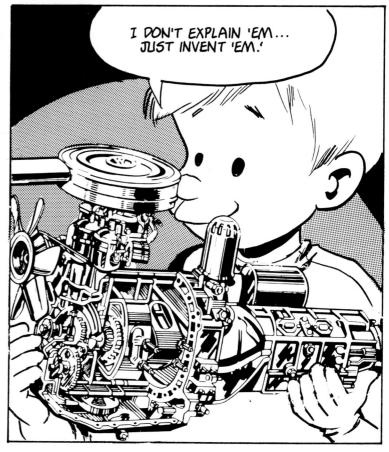

33

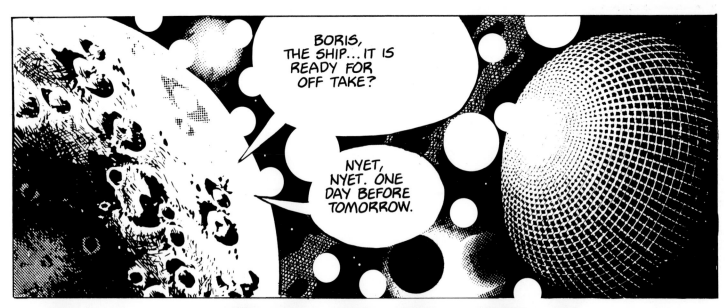

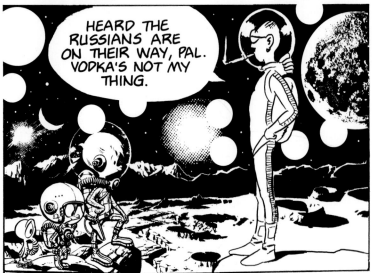

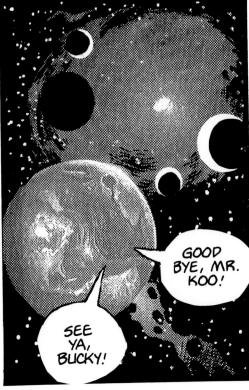

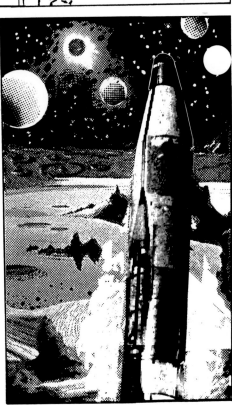

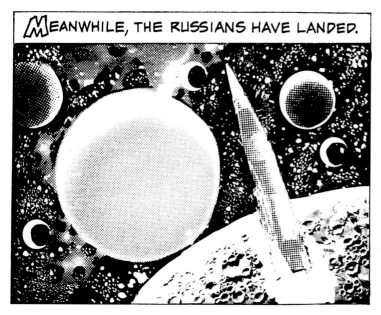

MEANWHILE, THE RUSSIANS HAVE LANDED.

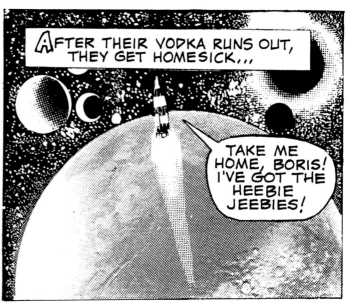

AFTER THEIR VODKA RUNS OUT, THEY GET HOMESICK...

TAKE ME HOME, BORIS! I'VE GOT THE HEEBIE JEEBIES!

WELL, AT LEAST THEY LEFT ME THIS NEAT MOON BUGGY.

WHAT'S THAT AHEAD?...LOOKS LIKE SOME SORT OF TOWN.

WIT'S END POP. 69½

A NICE PLACE TO LIVE BUT YOU WOULD'NT WANT TO VISIT HERE

½?

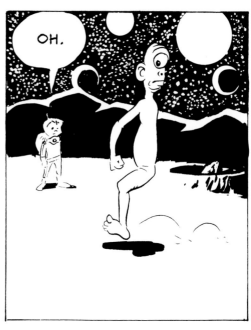

OH.

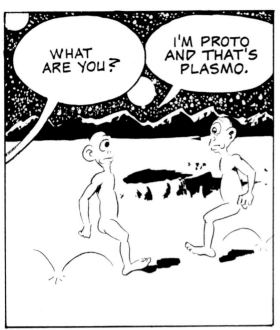
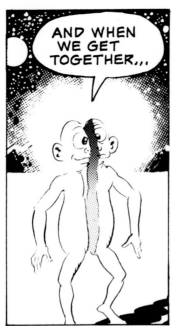
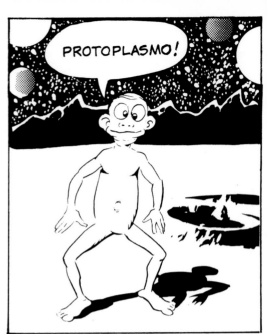
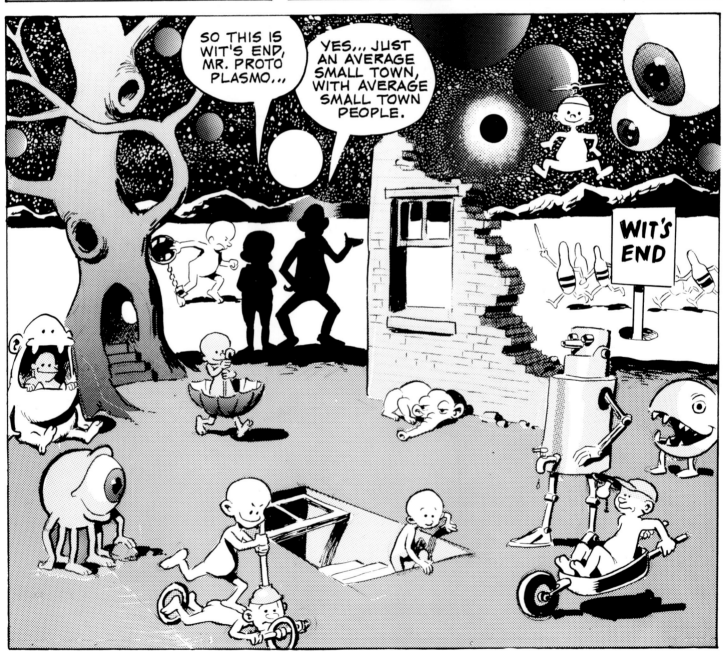

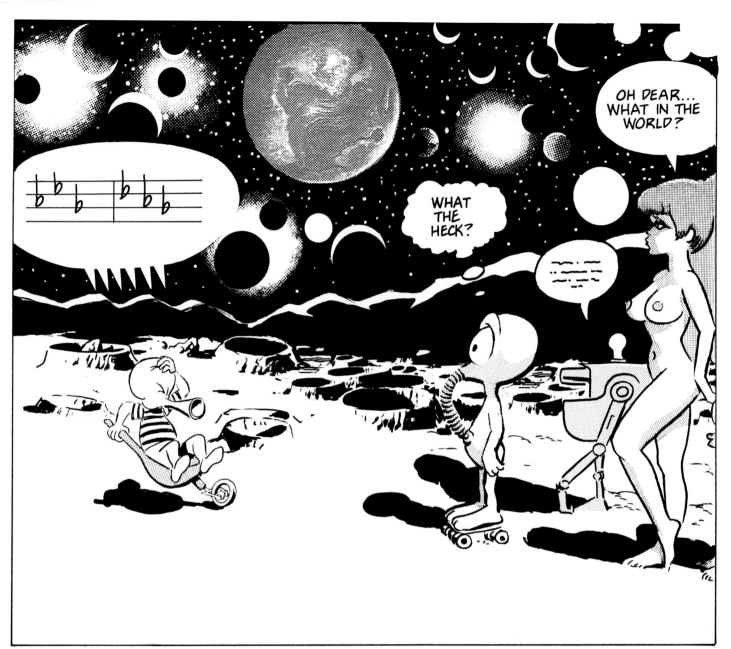

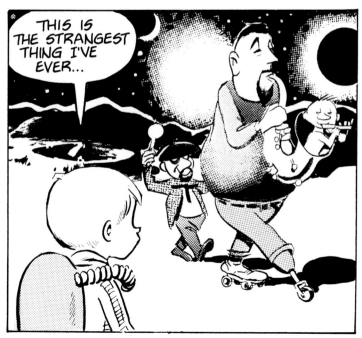

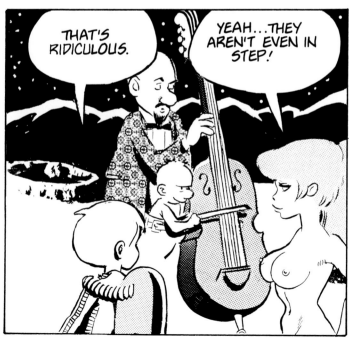

37

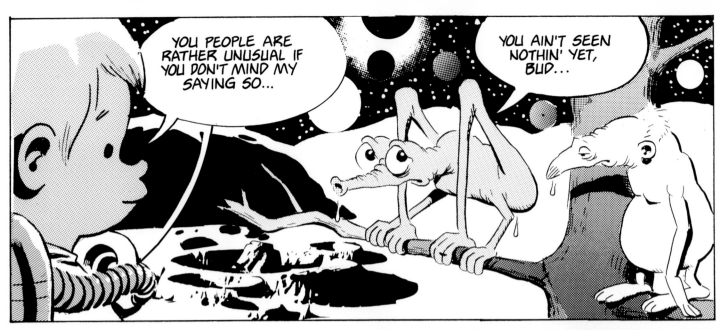

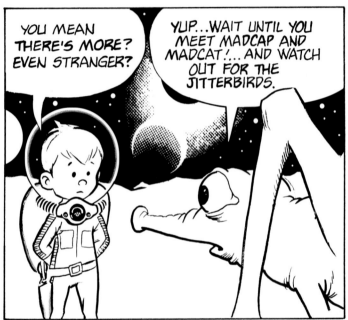

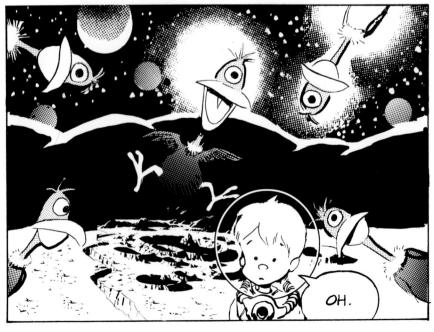

38

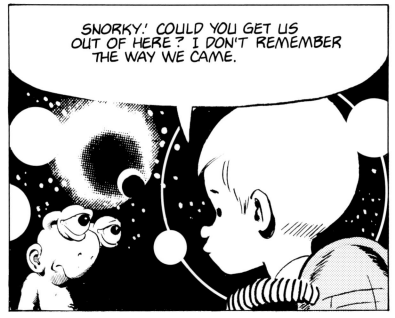

SNORKY! COULD YOU GET US OUT OF HERE? I DON'T REMEMBER THE WAY WE CAME.

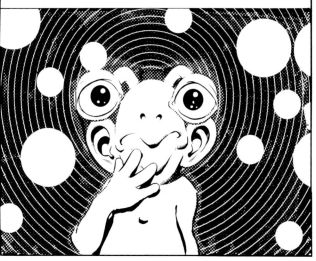

SNORKY CONCENTRATES, AND IMMEDIATELY A TEMPORSPATIAL VORTEX ENGULFS BUCKY...

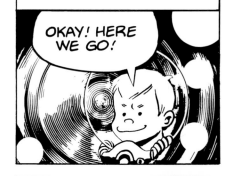

BUCKY, WITH THE TRUSTING SIMPLICITY INHERENT IN HIS ROLE AS A SUPER-HERO, PREPARES TO BE TRANSPORTED TO HIS POINT OF ORIGIN...

OKAY! HERE WE GO!

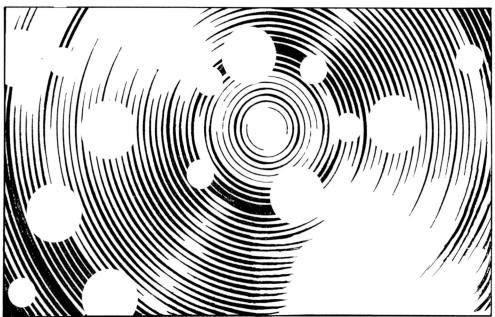

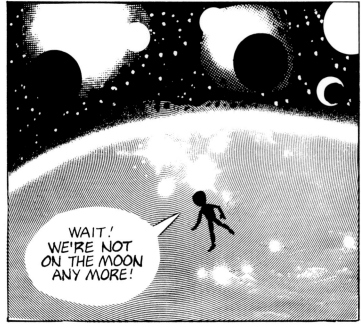

WAIT! WE'RE NOT ON THE MOON ANY MORE!

GOOD LORD!

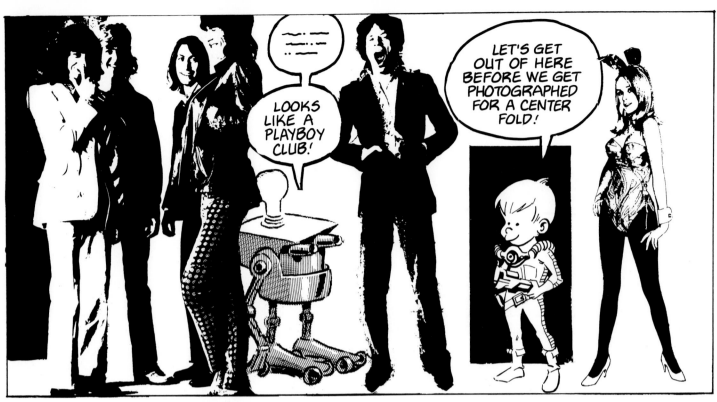

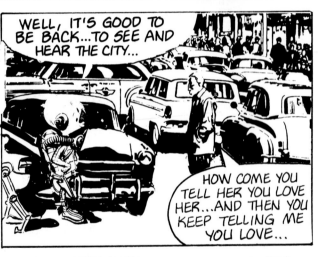

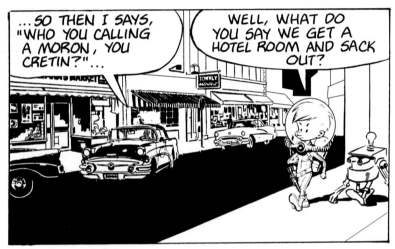

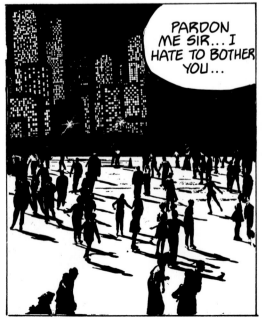

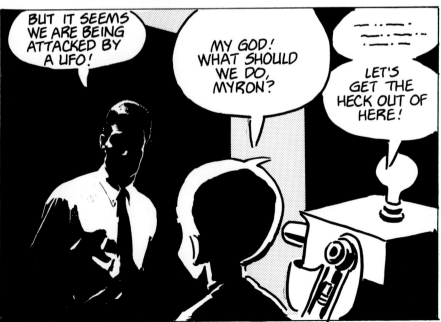

40

THE ALIEN SHIP MAKES ITS APPROACH.

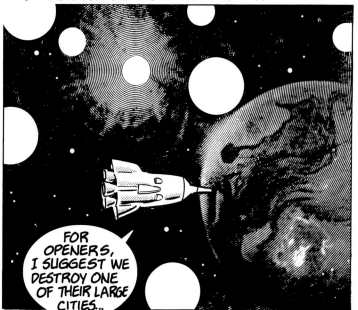

FOR OPENERS, I SUGGEST WE DESTROY ONE OF THEIR LARGE CITIES...

...AS THE CITY BLISSFULLY CHARGES ON WITH ITS NORMAL ROUTINE...

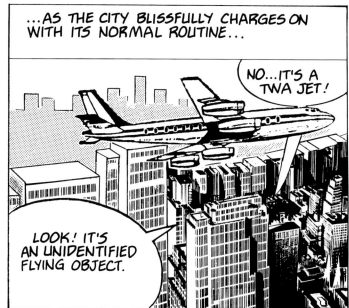

NO...IT'S A TWA JET!

LOOK! IT'S AN UNIDENTIFIED FLYING OBJECT.

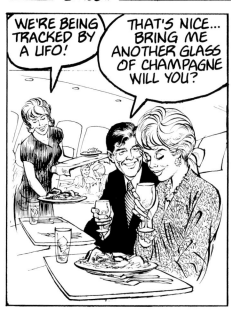

WE'RE BEING TRACKED BY A UFO!

THAT'S NICE... BRING ME ANOTHER GLASS OF CHAMPAGNE WILL YOU?

THE PUBLIC GRADUALLY BECOMES AWARE OF THE THREAT...

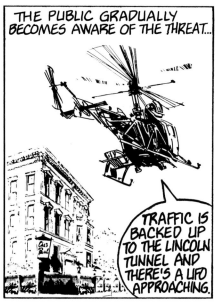

TRAFFIC IS BACKED UP TO THE LINCOLN TUNNEL AND THERE'S A UFO APPROACHING.

MY GOD! WE'RE ALL GOING TO BE KILLED! WHAT CAN WE DO, JACK?

RELAX, BRENDA... HAVE A NYTOL AND COME TO BED!

THE EVENT RECEIVES THE USUAL AMOUNT OF COVERAGE...

★ EXTRA ★ ★ ★

The New York Times

INFLATION UNDER CONTROL SAYS THE BUDGET DIRECTOR

SCIENTISTS REPORT UFO

The Menomonee Falls

SPACESHIP REA

BUCKY, YOU'RE OUR ONLY HOPE...CAN YOU SOMEHOW AVERT THIS THREAT?

I DON'T KNOW...I'LL TRY AND DO MY BEST, SIR!

THE UFO APPROACHES UNTIL IT IS VISIBLE TO THE NAKED EYE...

NO MISTAKE, IT'S HEADING STRAIGHT FOR NEW YORK!

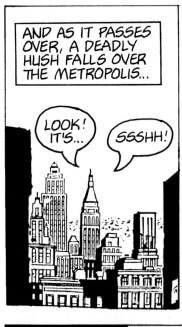

AND AS IT PASSES OVER, A DEADLY HUSH FALLS OVER THE METROPOLIS...

LOOK! IT'S...

SSSHH!

BLIMEY! I KNEW IT WAS A MISTAKE TO COME HERE, LADS!

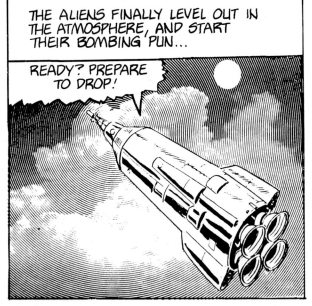

THE ALIENS FINALLY LEVEL OUT IN THE ATMOSPHERE, AND START THEIR BOMBING RUN...

READY? PREPARE TO DROP!

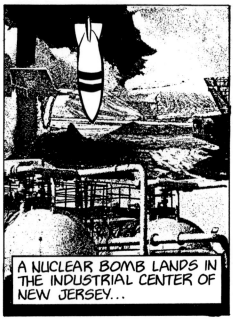

A NUCLEAR BOMB LANDS IN THE INDUSTRIAL CENTER OF NEW JERSEY...

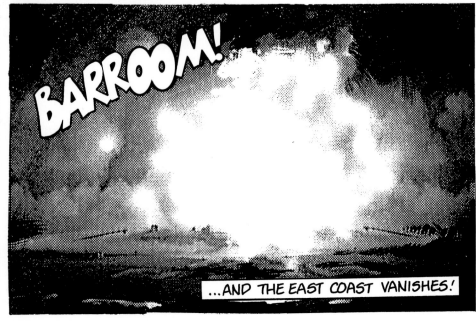

BARROOM!

...AND THE EAST COAST VANISHES!

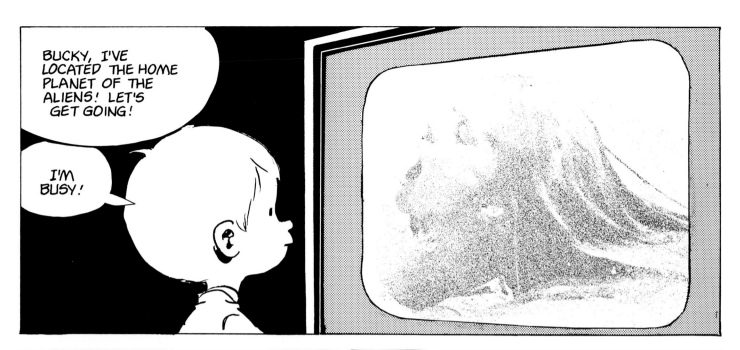

BUCKY, I'VE LOCATED THE HOME PLANET OF THE ALIENS! LET'S GET GOING!

I'M BUSY!

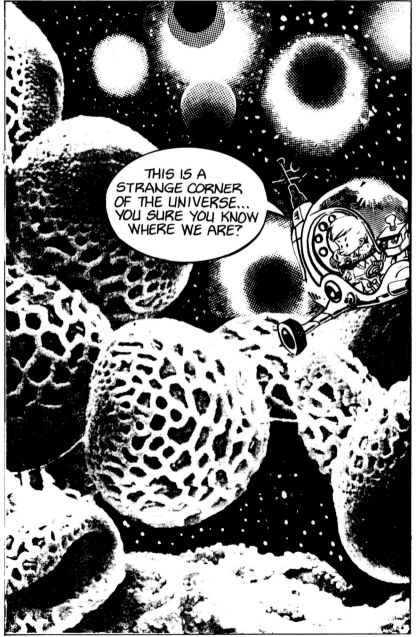

THIS IS A STRANGE CORNER OF THE UNIVERSE... YOU SURE YOU KNOW WHERE WE ARE?

THEY ZOOM OVER THE ALIEN LANDSCAPE OF A DOZEN STRANGE WORLDS AND ASTEROIDS...

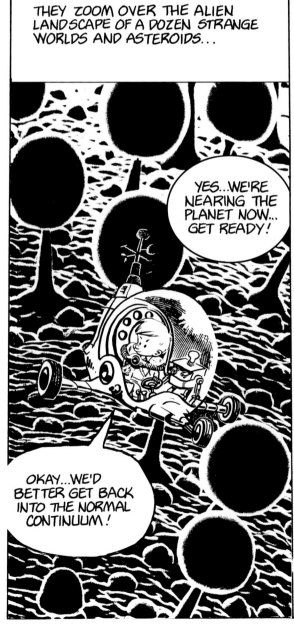

YES...WE'RE NEARING THE PLANET NOW... GET READY!

OKAY...WE'D BETTER GET BACK INTO THE NORMAL CONTINUUM!

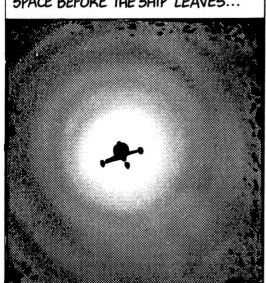

BUCKY'S SHIP ENTERS NORMAL SPACE BEFORE THE SHIP LEAVES...

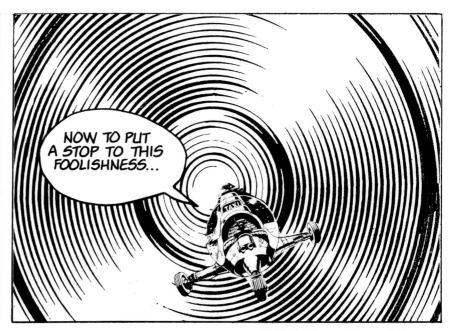

NOW TO PUT A STOP TO THIS FOOLISHNESS...

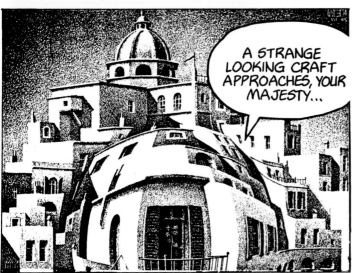

A STRANGE LOOKING CRAFT APPROACHES, YOUR MAJESTY...

NOW!

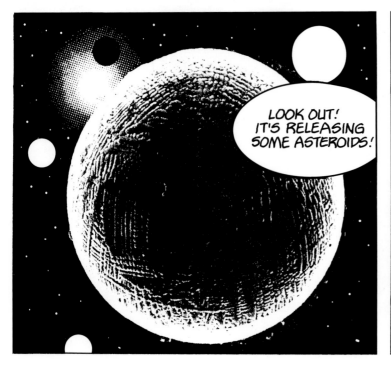

LOOK OUT! IT'S RELEASING SOME ASTEROIDS!

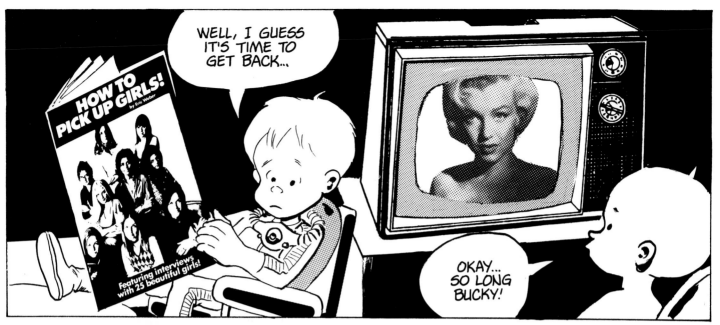

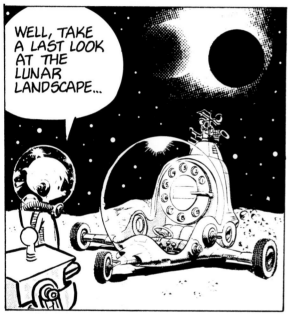

BUCKY AGAIN GOES INTO HYPERSPACE...

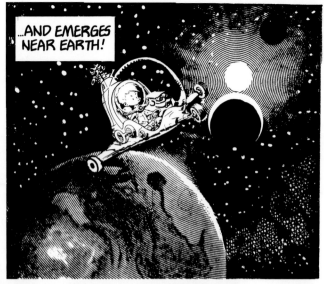

...AND EMERGES NEAR EARTH!

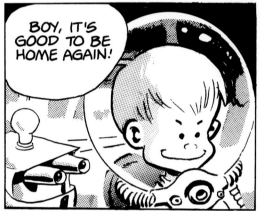

BOY, IT'S GOOD TO BE HOME AGAIN!

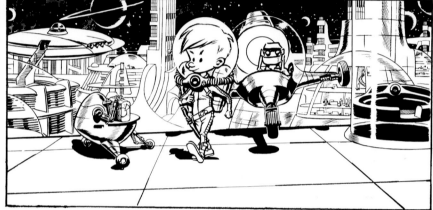

I'LL BET THE GANG IN L.A. WILL BE GLAD TO SEE ME...

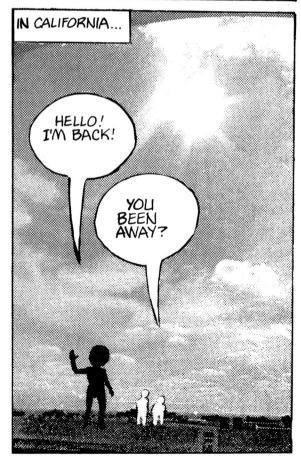

IN CALIFORNIA...

HELLO! I'M BACK!

YOU BEEN AWAY?

46

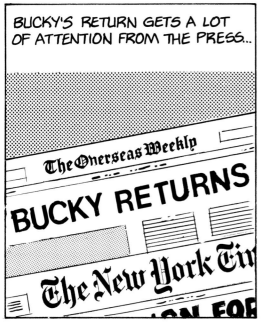

BUCKY'S RETURN GETS A LOT OF ATTENTION FROM THE PRESS...

The Overseas Weekly

BUCKY RETURNS

The New York Times

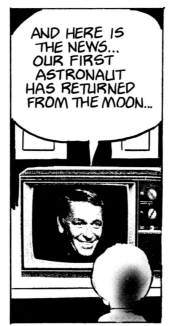

AND HERE IS THE NEWS... OUR FIRST ASTRONAUT HAS RETURNED FROM THE MOON...

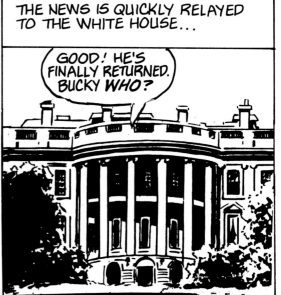

THE NEWS IS QUICKLY RELAYED TO THE WHITE HOUSE...

GOOD! HE'S FINALLY RETURNED. BUCKY *WHO?*

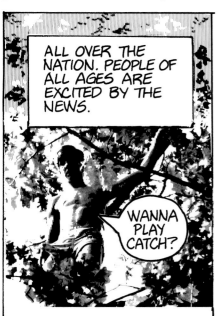

ALL OVER THE NATION. PEOPLE OF ALL AGES ARE EXCITED BY THE NEWS.

WANNA PLAY CATCH?

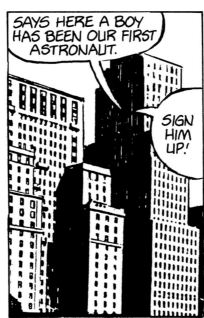

SAYS HERE A BOY HAS BEEN OUR FIRST ASTRONAUT.

SIGN HIM UP!

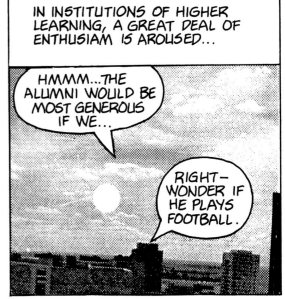

IN INSTITUTIONS OF HIGHER LEARNING, A GREAT DEAL OF ENTHUSIAM IS AROUSED...

HMMM...THE ALUMNI WOULD BE MOST GENEROUS IF WE...

RIGHT— WONDER IF HE PLAYS FOOTBALL.

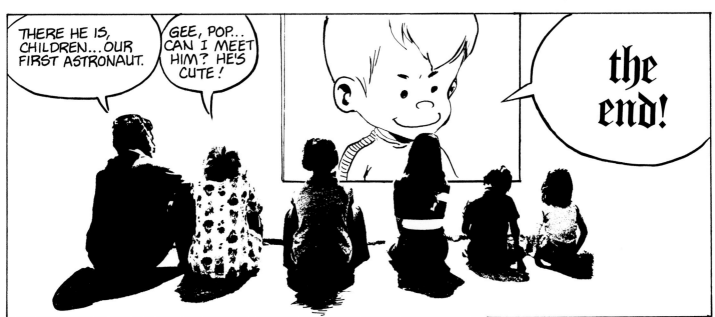

THERE HE IS, CHILDREN...OUR FIRST ASTRONAUT.

GEE, POP... CAN I MEET HIM? HE'S CUTE!

the end!

47

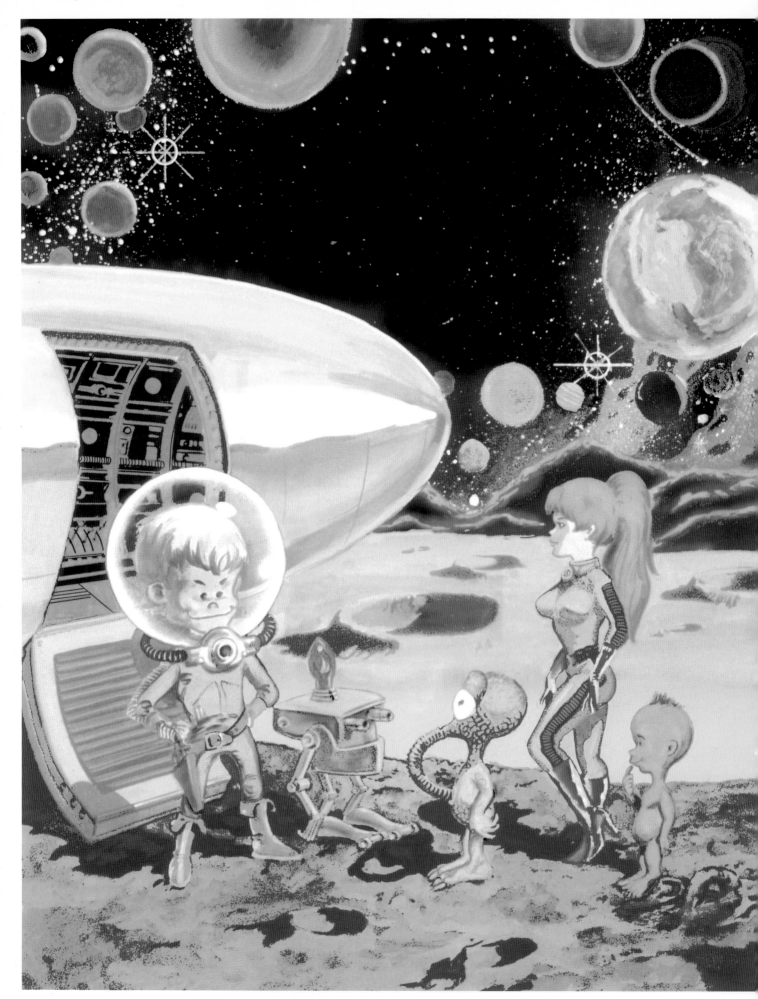